today's artist dvd series

DragonArt™ Drawing Workshop

J "NeonDragon" Peffer

IMPACT
CINCINNATI, OHIO
www.impact-books.com

Contents

Introduction

If you've picked up this book, chances are good that you're a fan of fantasy, myth and dragons. I must commend you on your most excellent taste! Inside you will find step-by-step demonstrations, breakdowns on pieces of anatomy, color theory and illustrations of ways that one could visualize these creatures of myth and magic.

I hope that you use these demonstrations as sources of inspiration and foundations for drawing and designing dragons. By no means let what's sandwiched between these pages limit your imagination or the many, many ways that you can design your own unique dragons!

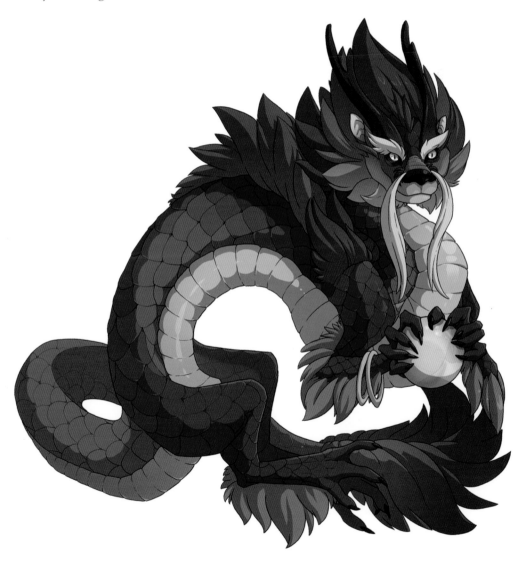

How to Use This Book

If you're familiar with my other books, you're well aware of how things work. But for the uninitiated, I offer this advice for working through the exercises. Each new step of each demonstration is denoted in red or green. Following along with the demonstrations will help you draw several different, truly extraordinary creatures. Don't be discouraged if your first efforts don't look exactly as you planned. Everything comes with practice.

The more you draw, the better you'll get. Through sheer repetition, your drawings will improve and your own personal style will emerge. If each drawing you make looks a little bit better than the previous one, you're getting somewhere.

So sharpen your pencils, find your softest eraser, prepare your trusty inking pen, and let's go!

1 Begin with a simple line of motion. Indicate the head, chest and hips with bubble shapes.

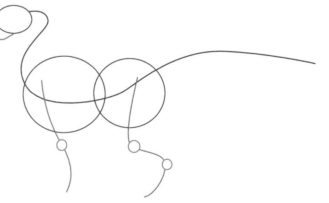

2 Add a snout to the head bubble. Place the legs under your dragon. If his legs sway too much to one side or the other, it will look like he's about to fall over.

Dragon Basic Shapes

First things first. Before you can dive into drawing beautiful beasts, you need to arm yourself with some drawing basics. The easiest way to think about drawing anything is to think of everything as shapes. Anything you would ever want to draw—tables, chairs, flowers or unicorns—consists of simple shapes.

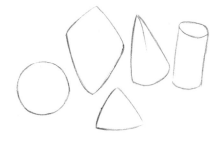

BASICS LEAD TO BEASTIES
Practice drawing these simple shapes before moving on to more complicated forms.

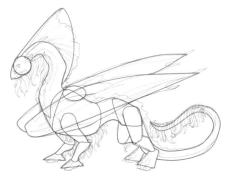 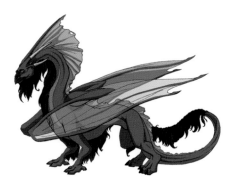

DRAWING ANY CREATURE BEGINS WITH BASIC SHAPES
Every dragon or creature you'll learn about in the pages to follow will begin with simple shapes such as these.

TOOLS YOU NEED

The wonderful thing about drawing is that you really don't need much—your own imagination is the most important thing. To get what's in your head down on paper, though, you will need:

• Some pencils and a pencil sharpener

• A kneaded eraser

• Paper

That's all that's required to propel yourself into fantasy-creature creation readiness!

Dragon Shading and 3-D Effects

Dragons appear more realistic when you draw them to look three-dimensional. It isn't as hard as it sounds. You just have to pay attention to darks and lights and how they affect your creature.

Consider first where the light is coming from. This is called the *light source*. Where the light source hits your dragon or other object is the lightest spot, called the *highlight*. The rest of your creature will likely be in some stage of shadow. As you develop your skills at shading the shadow areas, your creatures will begin to take on new life.

PRACTICE ON SIMPLE SHAPES

Polygons (shapes with three or more sides) will often have one side facing the light source. This side will be considerably lighter than those angled in a different direction. Sides that are completely cut off from the light will be very dark, giving you a harsh edge.

With round objects there is no clear definition of where things get cut off from direct light. The answer to this problem is fairly simple: because there's a gradual cutoff from the light, you will have gradual shadow with no harsh edges! Figure out where your light is hitting directly, and as things move farther away from that point of light, they should get darker.

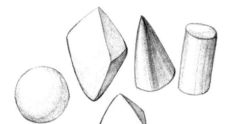

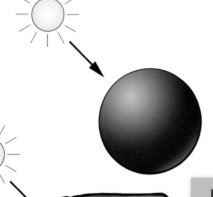

BE AWARE OF THE LIGHT SOURCE

Dragons, supreme though they are, remain solid, tangible objects that follow the same laws as everything else when it comes to light source. Lighting that comes from a single direction will yield highlights on the surfaces that it hits, and shadows on the areas blocked off from the rays.

Perspective and Overlap

Overlap is a great tool for creating *perspective*, the illusion of space, and is arguably one of the more important aspects to creating drawings full of depth. When you draw one object or part of an object overlapping another, the object in front automatically looks closer while the one in the back looks farther away. You can use overlapping objects to create a sense of perspective not only in individual creatures but also in whole scenes. Draw a mountain, then a house overlapping it followed by a dragon overlapping the house and you've got a foreground, middle ground and background. Once those are clearly defined, you've got a believable drawing.

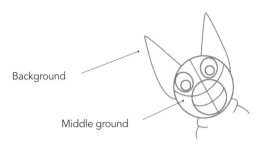

Background

Middle ground

OVERLAPPING DEFINES YOUR SPACE
Overlapping shapes help clearly define your foreground, middle ground and background and give friendly dragons like this one a clear sense of solidity.

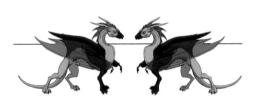

NO PERSPECTIVE OR OVERLAP
Without any overlap or perspective, it is difficult to get an idea of the scale of things. It is also difficult to think of the object as existing within a space.

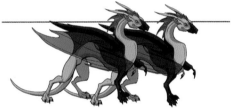

OVERLAP GIVES A SENSE OF ORDER AND GROUND
Overlap provides a sense of space. The brain registers that one object must be in front of the other.

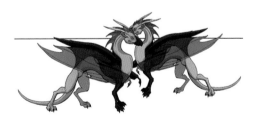

OVERLAP PLUS SIZE VARIATION PROVIDE MORE PERSPECTIVE
The green dragon is smaller than the brown. When we see it though, we don't think he's actually smaller than the brown. We just assume he's farther back in the space that they share.

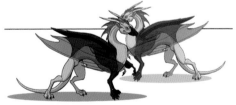

OVERLAP PLUS SIZE VARIATION PLUS ATMOSPHERE EQUALS PERSPECTIVE TO THE MAX!
Atmospheric perspective means that things that are closer appear brighter, have greater contrast and look more in focus. As they recede, all these effects fade. Using all three perspective techniques gives the viewer a good sense of depth.

Dragon Horns

You can create a huge variety of shapes and sizes when drawing horns, from large spirals to a series of short spikes. Do not let what's on these pages limit you. There are thousands of different horns that you can draw!

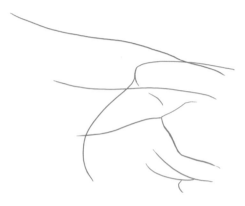

1 Draw a set of three lines that extends from the edge of the eye, cheek and lower jaw. Each line should have a gentle curve.

2 Add a lower edge to each horn that leaves the horn thick at the base and allows it to taper to a point at the end.

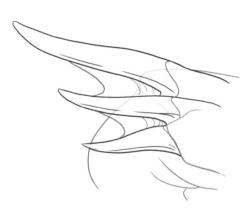

3 In between the set of three horns, add some webbing or leave it plain.

4

Dragon Snout

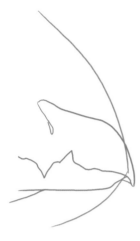

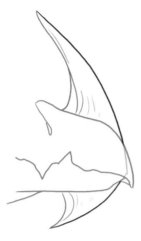

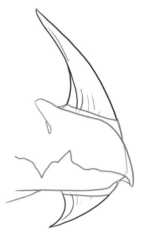

1 On the end of the snout, draw a pair of curving lines that branch out in either direction.

2 Add the other edge to each horn that leaves the spike thick at the base and pointed at the tip.

3 You can add a thin ridge of skin around where your horn meets the snout of the dragon.

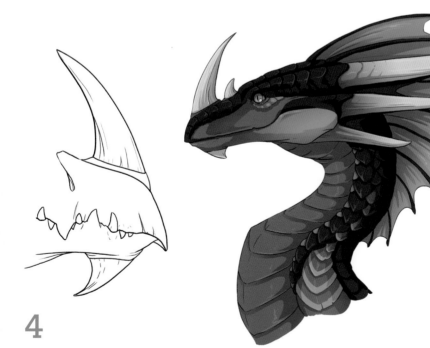

4

Dragon Wings

The wings will often take up a large portion
of any canvas that you draw your dragon on,
so having a pair with flair is important!

1 Draw a loose skeleton
that shows the shoul-
der, elbow and "hand."
Create 1–2 branches from
the elbow and 4–5 from
the hand.

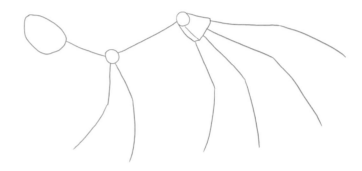

2 Create a thick,
muscled shoulder,
flesh out the arm of the
wing, and create a series
of thin, delicate "fingers"
for the wing membrane to
stretch across.

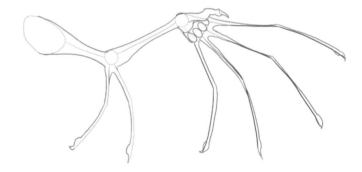

3 Draw gentle U shapes
between each set
of fingers. You may also
create a flap of skin that
stretches from wrist to
shoulder for extra surface
area for your dragon to
glide with.

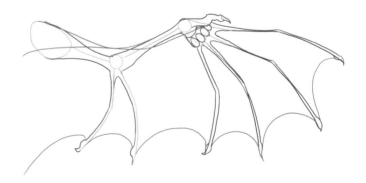

4 Add details such as little wrinkles where the skin is bunched up, particularly around the joints.

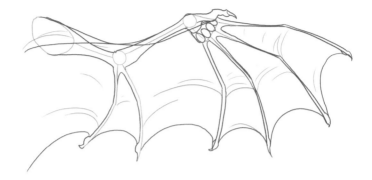

5 Erase any stray construction lines and put down the final pencils or inkwork for the wing.

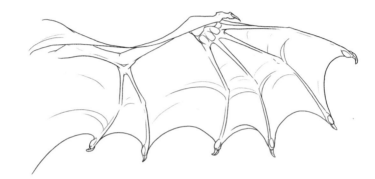

Dragon Scales

Many dragons are based on the idea of a large flying reptile, so a scaled hide can be just as appropriate as a leather hide. Putting scales and plating on your dragons allows for further design customization, and the type of scales you use affects the final look.

You can use scales all of the same type or combine many different types of scale for an elaborate pattern. When putting scales—or any details—on your dragon, plan in advance what type of look you're going for.

SCALE PATTERN 1
This pattern is based around a series of half ovals.

1 The bottom of each oval is where the next row of ovals begins.

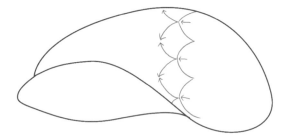

2 Continue wrapping the pattern around the body and limbs.

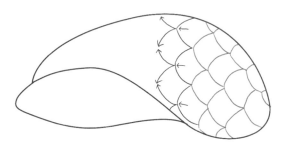

3 Create bumps and indentations along the edges of your initial shapes for a 3-D feel.

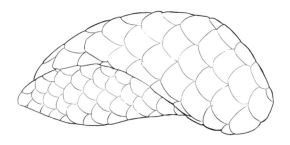

SCALE PATTERN 2

This flat scale pattern requires a touch of preplanning.

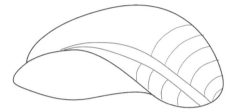

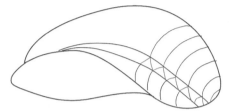

1 Create two guidelines located between each row of scales. Once these are in place, curve a series of lines around the shapes creating the rows of scales.

2 The small space you created the guides for will be used to finish off the edge of each scale. Link each scale to the corner of another above it on the opposing side. This makes the scales interlock.

3

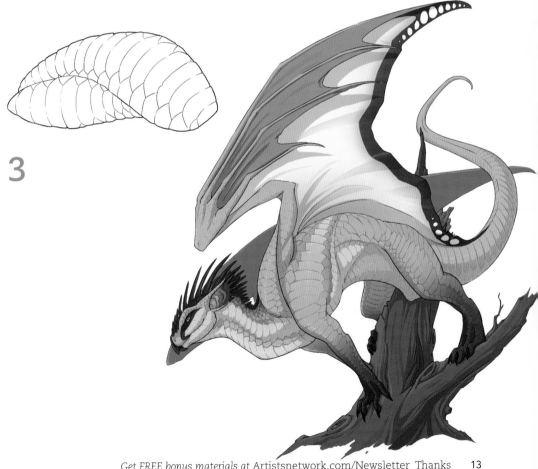

Dragon Limbs

Making sure that your dragon's limbs have good proportions, skeletal structure and musculature will help ensure their believability. (Legs need to capable of bearing dragon weight.) Also keep in mind when coloring that, most often, dragon limbs are the same color as the rest of the body.

LEGS
Let's kick off this unit with a basic leg.

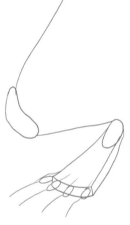

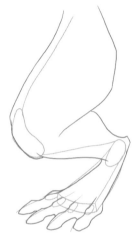

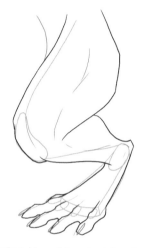

1 The framework gets a knee bend from thigh to calf and from ankle to digitigrade foot. (The dragon walks on its toes.)

2 Add a thick thigh, a gently curving calf, and a foot with the toes spread out evenly over the ground.

3 Add small lines to define the muscles under the skin, the knobby knee, and sharp claws on each toe.

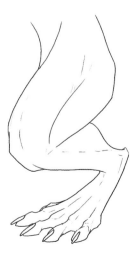

4 When you shade and color the leg, you can define the muscles of the leg as much, if not more so, with shadow than you do with line work.

ARMS

Now let's do a simple arm with an opposable thumb, much like our own.

1 Lay down a framework that has a shoulder connected to an elbow, connected to a wrist, connected to a hand with four fingers and a thumb.

2 Expand the arm so that it has a thicker upper arm, medium-sized lower arm, and delicate fingers.

3 Gently lay in the musculature of the arm. You don't have to put in super thick lines to get the point across. If you decide to shade this drawing, you can define much of the anatomy with shadow only.

4

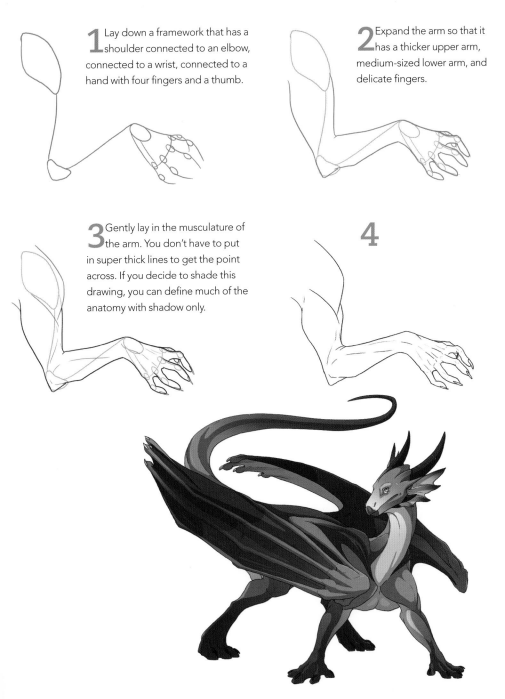

Medieval Dragon

We're going to try drawing a dragon's head from the side, a profile view.

1 Draw a simple circle for the skull, a snout, and a flowing line to show the curve of the neck. Make sure that your first marks are where you want the head to be on the page.

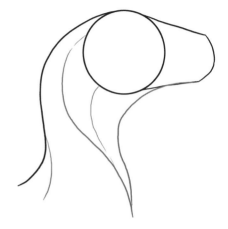

2 Flesh out the neck into a 3-D object.

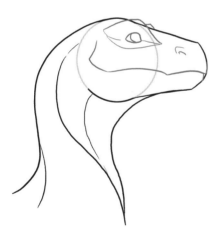

3 Break up the head into an upper and lower jaw. Rough in the eye and nostril. Since you are drawing only one side of the dragon, don't worry about symmetry.

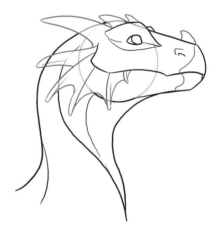

4 Use spikes, horns, frills, beaks and scales to create an original dragon straight out of your imagination!

Horned Head: Side View

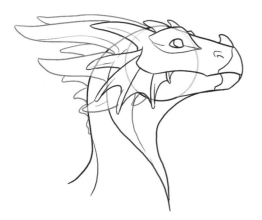

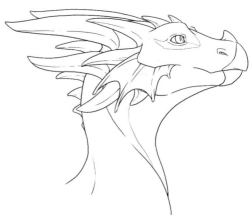

5 Add more rows of horns. For a profile view, create a few horns on the other side of the dragon's head to mirror the side we're seeing.

6 Tighten up your drawing and add the final details.

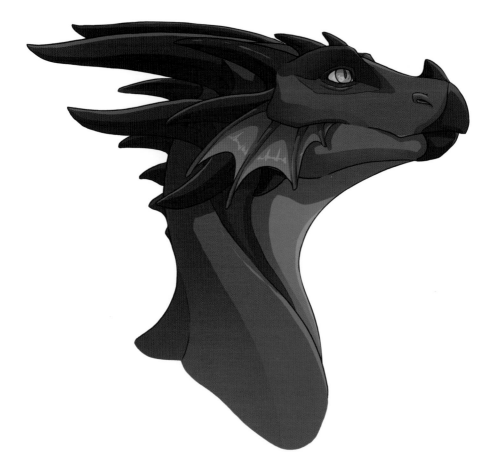

Medieval Dragon

A front view of your dragon's head must be symmetrical and take into account the foreshortening that affects the view.

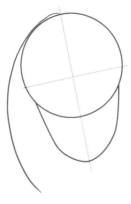

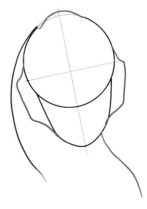

1 Draw a circular shape that extends to the back of the skull, a snout, and a line that shows the direction of the neck curves. Split the face down the center with a vertical line for two evenly spaced halves. Put a horizontal line perpendicular to the vertical center line where you want the eyes to go.

2 Draw the back of the jaw. Keep both sides roughly the same size. Draw the other side of the neck loosely following the same curve as the back of the neck.

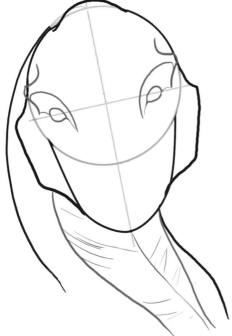

3 Add the eyes, spacing them an equal distance from the center line. These are facing forward. If your dragon's eyes naturally look forward, you will be able to see a large section of the eye. If the eyes are on the side of its head like a lizard, then they will face sideways, and from the front you will only see the sides. I decided that my dragon has a different belly texture from the scales that cover his back.

Crest Head: Front View

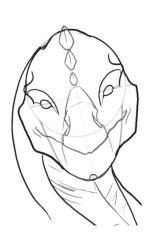

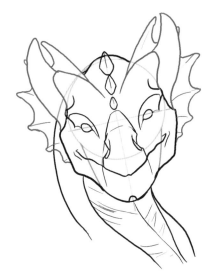

4 Divide the snout into an upper and lower jaw. Add details into the muzzle such as nostrils and a cleft chin.

5 Add horns, fins, whiskers, manes or whatever facial details you want. I chose a set of gently curved horns and a crest that runs along behind them. Make sure that the details are symmetrical so the face isn't lopsided.

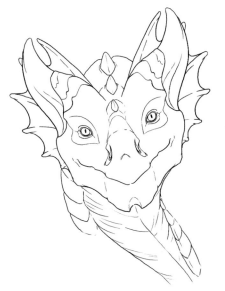

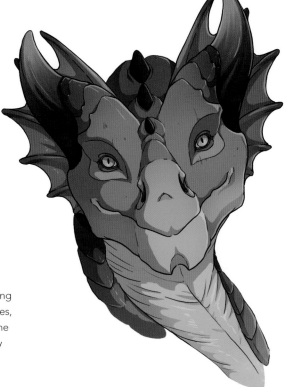

6 Tighten up the drawing and add any remaining details you would like, such as individual scales, wrinkles in the skin, tiny divots in the jaw. This is the time to go wild! When you are finished, erase any stray construction lines.

Medieval Dragon

In most illustrations it will be pretty rare to have your dragon facing perfectly forward or be in perfect profile. Often he will be positioned in a way that falls somewhere in between.

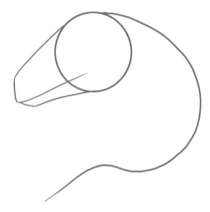

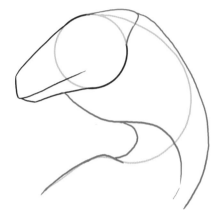

1 Draw where you'd like the snout to be and a loose guide that shows the way the neck bends. Draw a circular shape that extends to the back of the skull from the snout. This is an important step. You do not want your dragon's head to abruptly end once the mouth is finished. Leaving space for the skull means your dragon can have fun things like a brain and a hinge for his mandible.

2 Thicken the neck and connect the head to it.

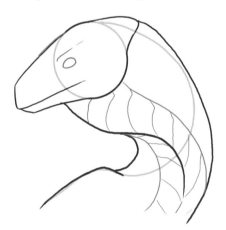

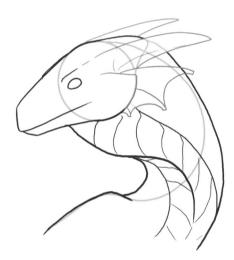

3 Add an eye. I wanted my dragon to have a raised bony brow structure that sits above its eye. Draw a complete brow on the side of the dragon facing us. On the side that's facing away, only a little bit of this brow would show over the top of his head, so I drew in this tiny sliver of brow.

4 Any details that you add to the side of the head facing us will also need to be added to the side of the head facing away. Figure out which pieces would be visible from this angle. Here, the horn sticks out far enough and is raised high enough on the head that the top and tip of it would be visible from this angle. The crest does not poke out far enough and is located too far down on the jaw to be seen on the other side.

Spike Head: 3/4 View

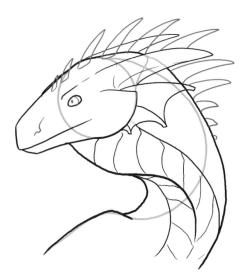

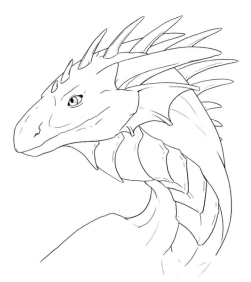

5 Work your way down to the small stuff. Add pupils to show which direction your dragon is looking, nostrils, and a spiked ridge down his spine.

6 Tighten up your lines and add tiny details, such as the individual shapes of the belly scales, the lines of the upper and lower eyelids, and the play of the muscles in your dragon's neck. Erase any stray construction lines.

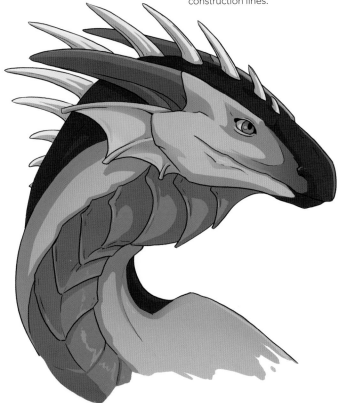

Dragon Hatchlings

Western dragon hatchlings often walk on four limbs and have a pair of batlike wings on their backs. They may not yet sport a full set of horns on their heads, but these grow in with time. They may not be able to breathe fire at this early age, but rest assured that when they grow up, they will go from being little terrors to being…large and terrible!

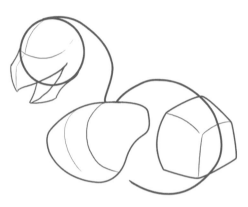

1 Place the skull, chest, hips and a line to represent the spine.

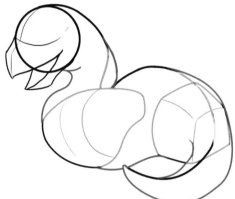

2 Draw the neck, body and tail. Keep it plump and pudgy!

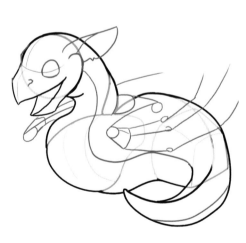

3 Add a pair of large eyes and sketch in the framework for a pair of stubby wings. This baby is not yet ready for flight.

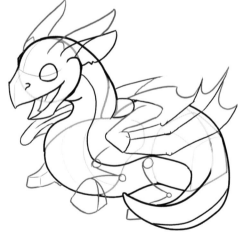

4 Add a membrane stretched between the wing's spines, and put down a quick framework for the legs. Remember that the legs may be stubby, but the baby might still have big paws, like a puppy.

Western

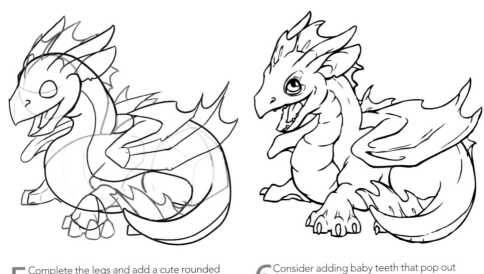

5 Complete the legs and add a cute rounded crest on its neck and tail.

6 Consider adding baby teeth that pop out through the gums. Really play up the large reflective eyes. Little details like this will help emphasize that your hatchling is young.

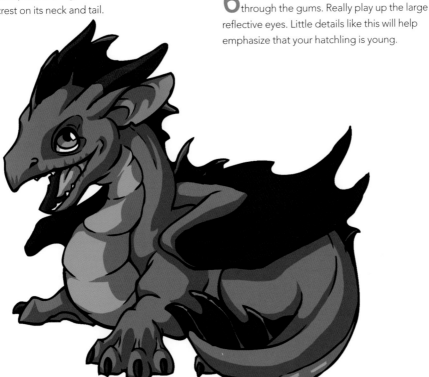

7 Your hatchling may share the exact same coloring as the dragon it will turn into, or it may be a duller version of the color to help camouflage it for protection while it is young and vulnerable.

Dragon Hatchlings

The smallest of the dragons starts out tinier than you might be able to imagine! Your baby fae dragon will mimic an adult in miniature. Its wings may not yet be fully functional or brightly colored.

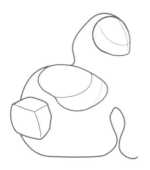

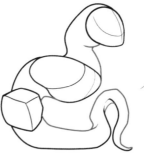

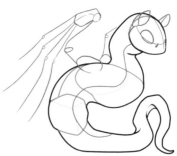

1 Place the skull, chest, hips and a line to represent the spine.

2 Pencil in the rest of the plump body.

3 Add enormous eyes and tiny rounded ears. The muscles around the wing connection may not be as bulky as that of an adult dragon.

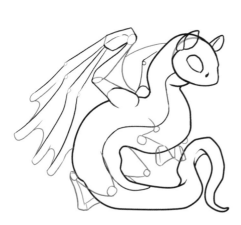

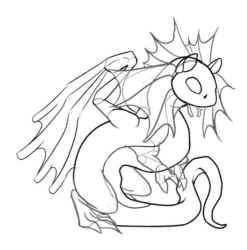

4 Connect the spines of the wings with gentle U shapes, forming the membrane stretched between them. Don't extend the U shapes up too far into the wing to avoid them looking too sharp and dangerous. Sketch in some guides for the short legs.

5 Add in any crests or decoration that you desire. Complete the limbs.

Fairy

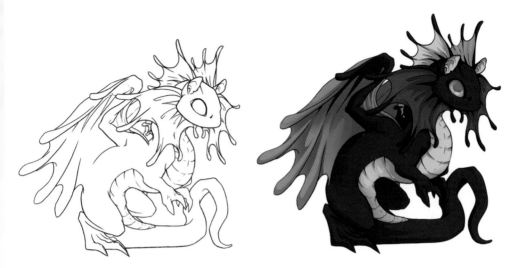

6 While most of this baby is small and round, make some things bigger, like a pair of loppy, oversized crests behind the ear. This will help convey the age of the dragon.

7 Remember, the hatchling's color may mimic an adult or he may be a bit more plain, lacking elaborate patterns and bright colors.

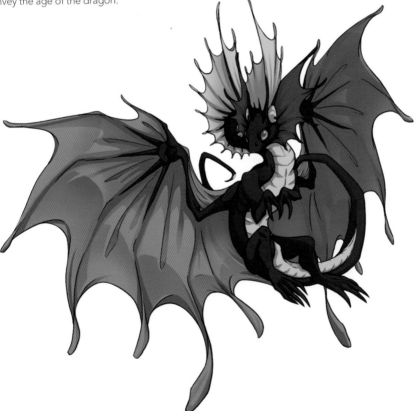

Medieval Dragon

 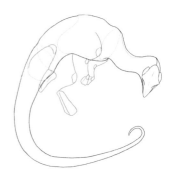

1 Establish the curve of the spine and tail and the placement of the head, chest and hips.

2 The neck will often widen slightly where it meets up with the head and body. The tail should gradually taper to a point.

3 Sketch quick lines for the leg placement. I've settled on shorter front legs and longer, powerful back legs. If you don't like how a leg is bending, erase it and try something different.

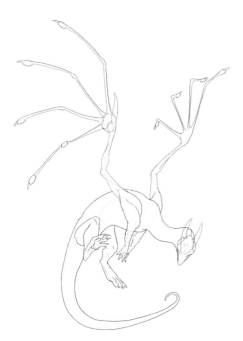 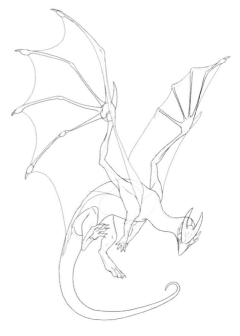

6 Give the wing framework some thickness. Consider adding small nails or claws to the tips of each "finger." Carefully draw the powerful muscles that connect the wing to the body. Add a pair of matched horns to your dragon's head.

7 Using a series of wide U shapes, connect the fingers of the wing, forming the membrane that stretches along the wing frame. Draw the membrane far down the body connecting to the tail to give your dragon a large area of wing to fly with.

Full Dragon

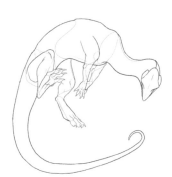

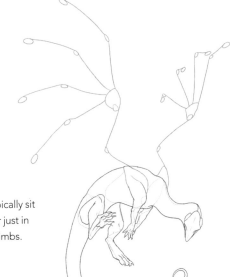

4 Consider where the muscles make a subtle curve in the calves, or where an elbow or wrist will have the bone close to the surface and create a small knob.

5 The wings typically sit just behind or just in front of the front limbs.

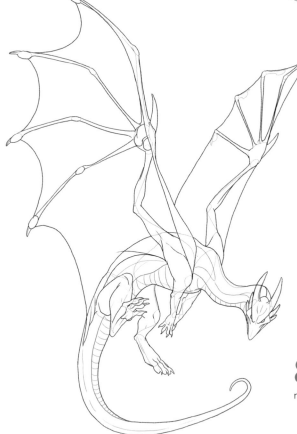

8 Work on body details such as belly scales and skin ripples.

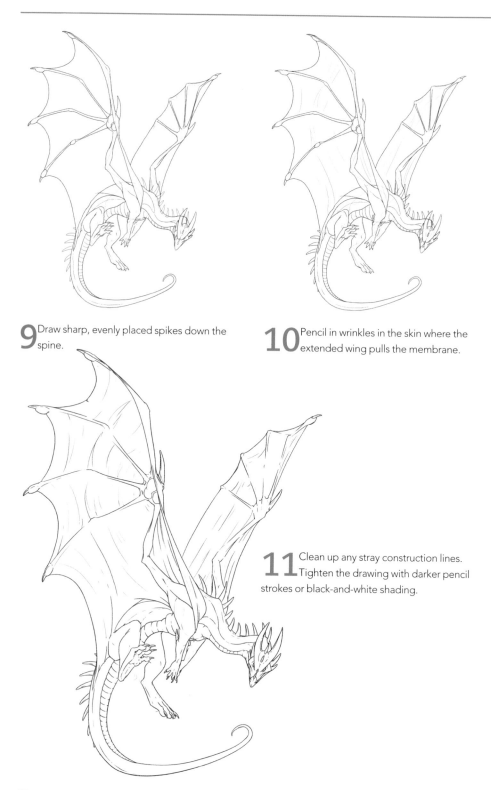

9 Draw sharp, evenly placed spikes down the spine.

10 Pencil in wrinkles in the skin where the extended wing pulls the membrane.

11 Clean up any stray construction lines. Tighten the drawing with darker pencil strokes or black-and-white shading.

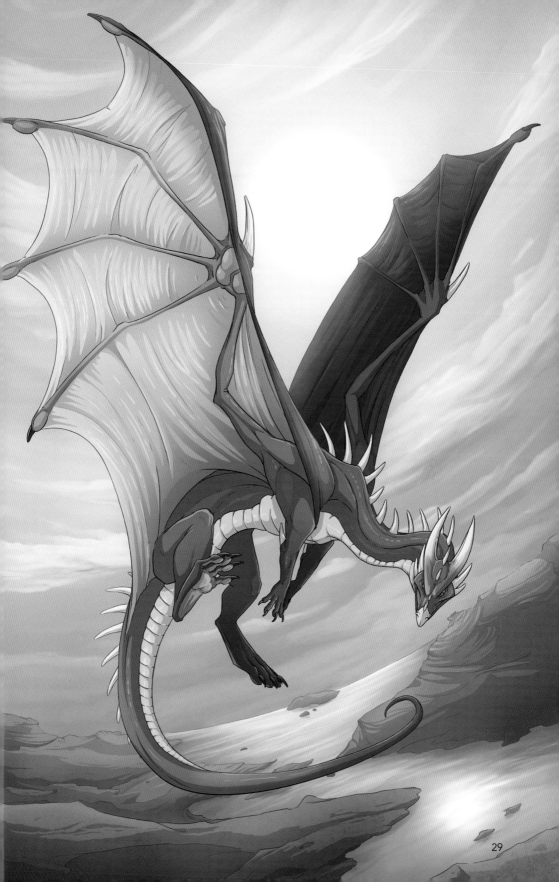

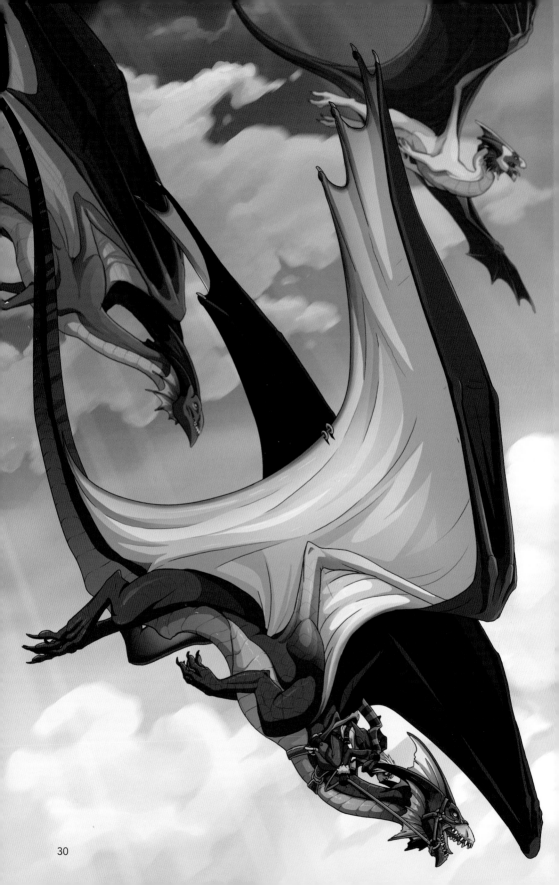

This work was compiled from the following previously published IMPACT Books.

DragonArt™ Evolution © 2009 J "NeonDragon" Peffer

DragonArt™ © 2005 J "NeonDragon" Peffer

ABOUT THE AUTHOR

J "NeonDragon" Peffer is a fantasy art illustrator and author of IMPACT's *DragonArt™: How to Draw Fantastic Dragons and Fantasy Creatures* and *DragonArt™: Fantasy Characters*. She runs a popular website, neondragonart.com, a community where fantasy art fans explore her art, comics, art instruction tutorials, products featuring her art, message boards, links and other features. She is a graduate of the Columbus College of Art and Design. She has also done character and logo commissions.

Today's Artist: DragonArt™ Drawing Workshop. Copyright © 2011 by J "NeonDragon" Peffer. Manufactured in China. All rights reserved. No part of this book may be reproduced in any form or by any electronic or mechanical means including information storage and retrieval systems without permission in writing from the publisher, except by a reviewer who may quote brief passages in a review. Published by IMPACT Books, an imprint of F+W Media, Inc., 10150 Carver Rd, Blue Ash, OH 45242 (800) 289-0963. First Edition.

 Other fine IMPACT Books are available from your favorite bookstore, art supply store or online supplier. Visit our website at www.fwmedia.com.

15 14 13 12 11 5 4 3 2 1

DISTRIBUTED IN CANADA BY FRASER DIRECT
100 Armstrong Avenue
Georgetown, ON, Canada L7G 5S4
Tel: (905) 877-4411

DISTRIBUTED IN THE U.K. AND EUROPE
BY F&W MEDIA INTERNATIONAL, LTD
Brunel House, Forde Close, Newton Abbot,
TQ12 4PU, UK
Tel: (+44) 1626 323200, Fax: (+44) 1626 323319
Email: enquiries@fwmedia.com

DISTRIBUTED IN AUSTRALIA BY CAPRICORN LINK
P.O. Box 704, S. Windsor NSW, 2756 Australia
Tel: (02) 4577-3555

Designed by Wendy Dunning
Production coordinated by Mark Griffin

METRIC CONVERSION CHART

To convert	to	multiply by
Inches	Centimeters	2.54
Centimeters	Inches	0.4
Feet	Centimeters	30.5
Centimeters	Feet	0.03
Yards	Meters	0.9
Meters	Yards	1.1

More DragonArt™

These and other fine IMPACT products are available at your favorite art & craft retailer, bookstore or online supplier. Visit our website at impact-books.com.

Receive **FREE** downloadable bonus materials when you sign up for our free newsletter at **artistsnetwork.com/Newsletter_Thanks**.

IMPACT-BOOKS.COM

- ▶ Connect with your favorite artists
- ▶ Get the latest in comic, fantasy and sci-fi art instruction, tips, techniques and information
- ▶ Be the first to get special deals on the products you need to improve your art

Get the latest updates, free downloads and more!

FOLLOW US!